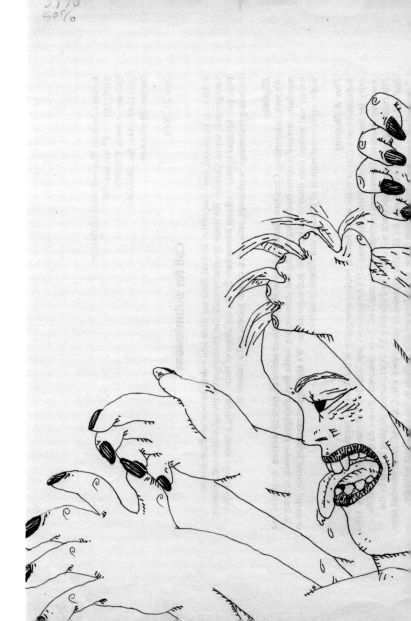

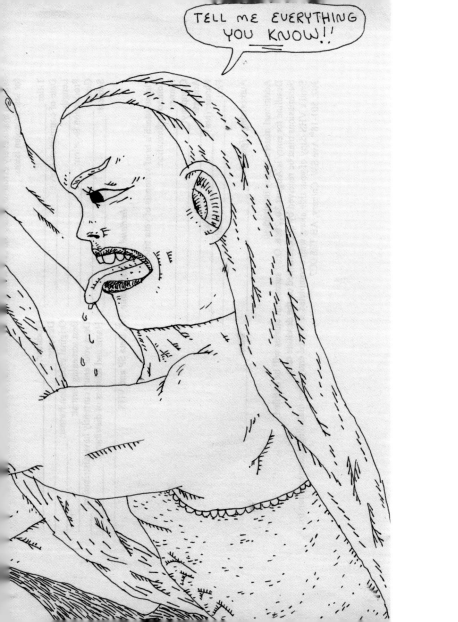

55%

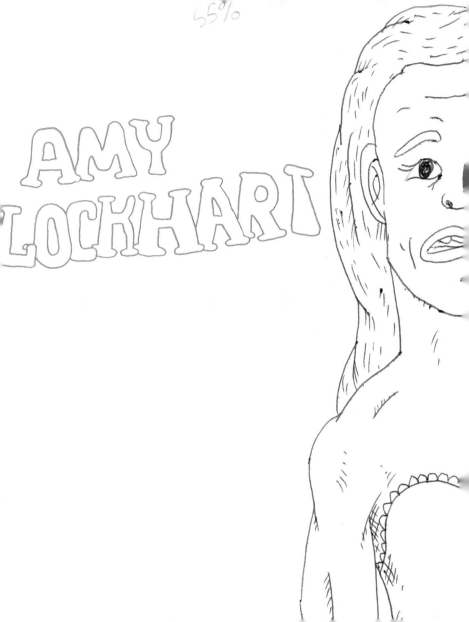

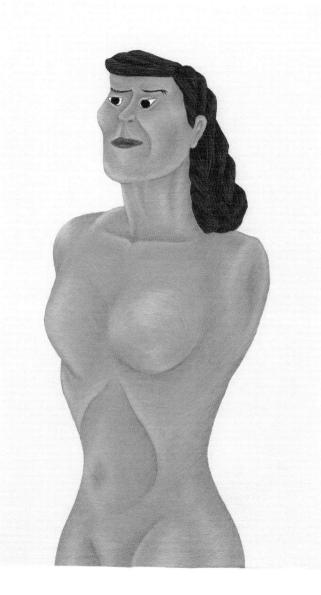

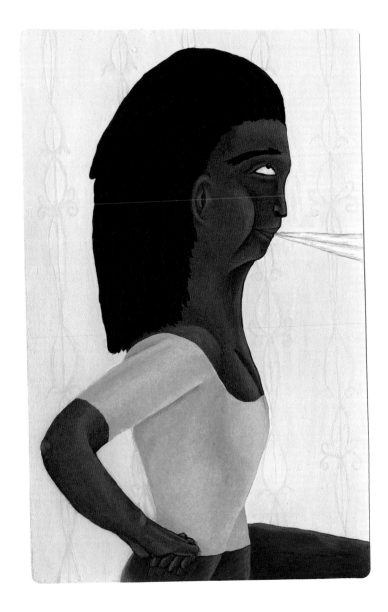

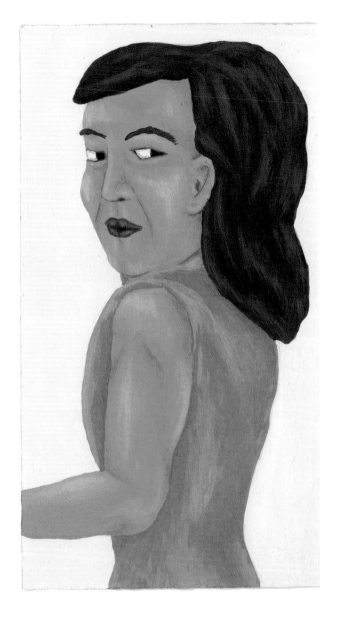

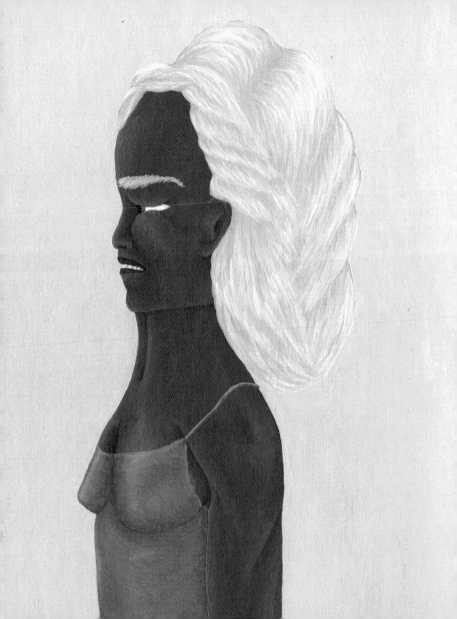

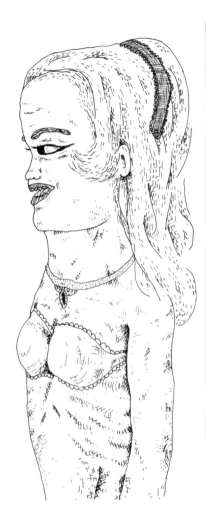

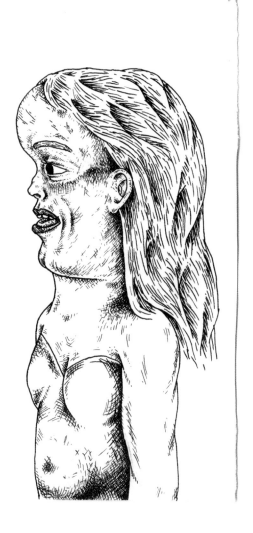

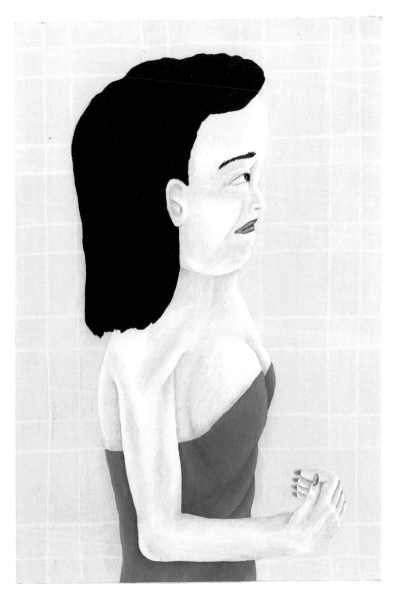

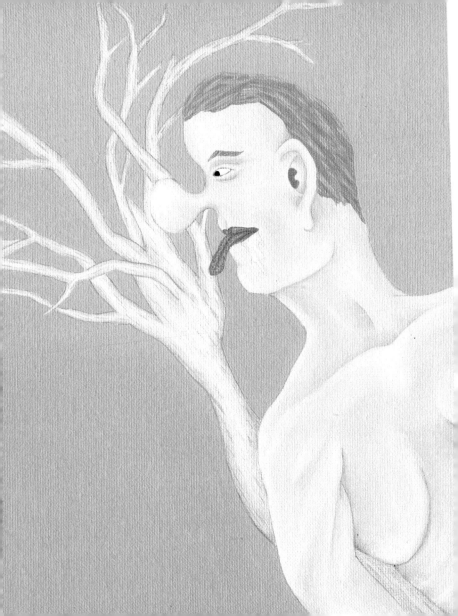

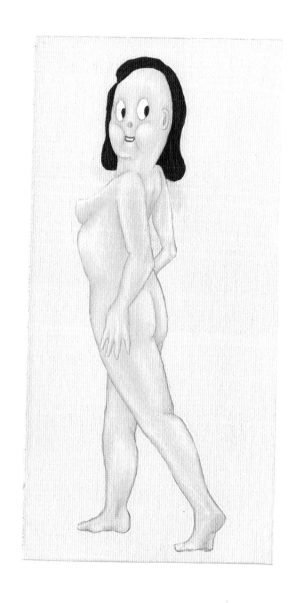

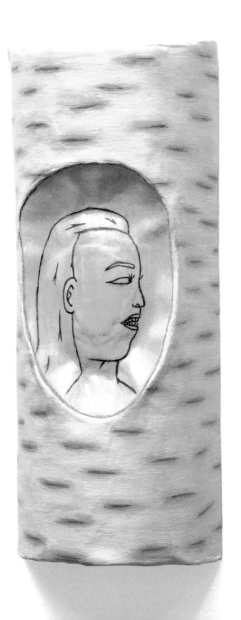

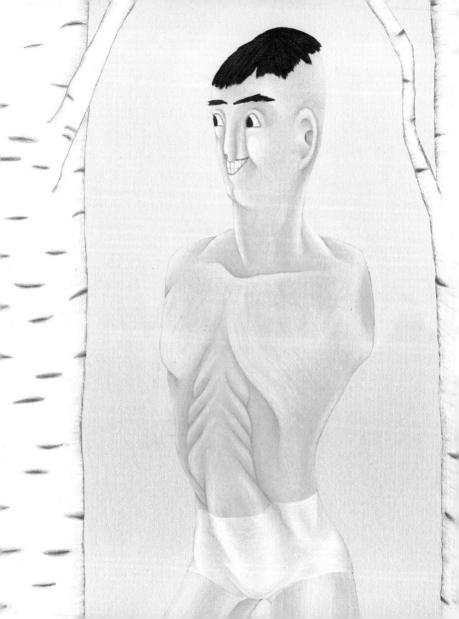

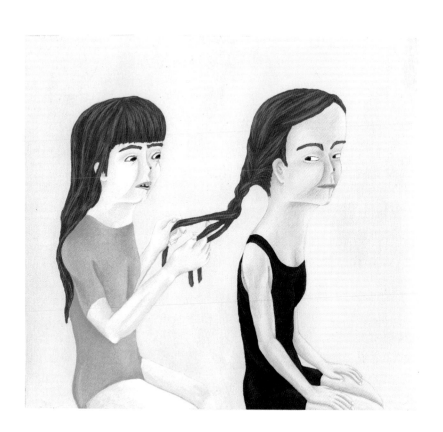

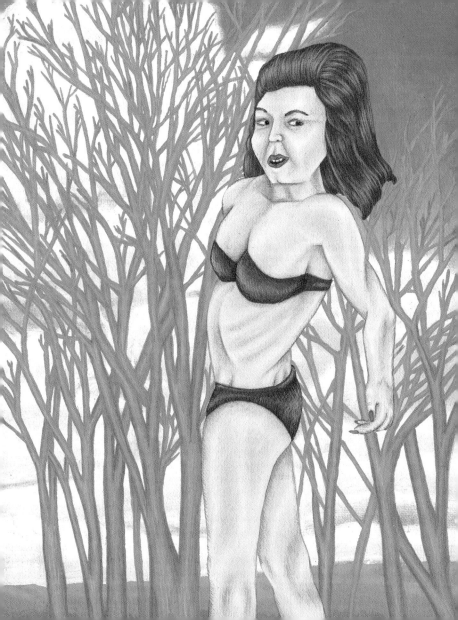

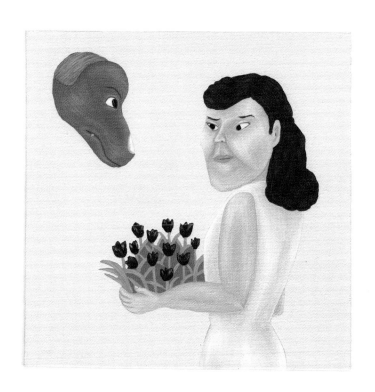

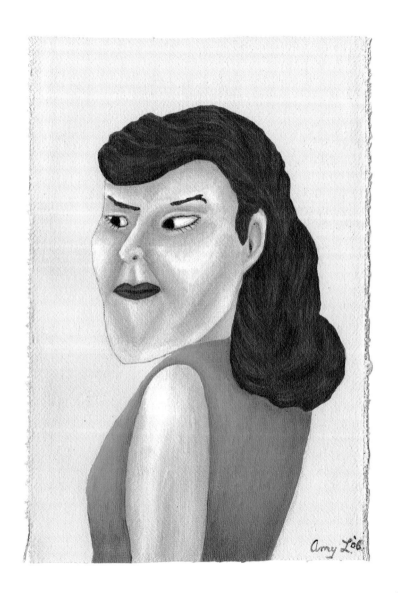

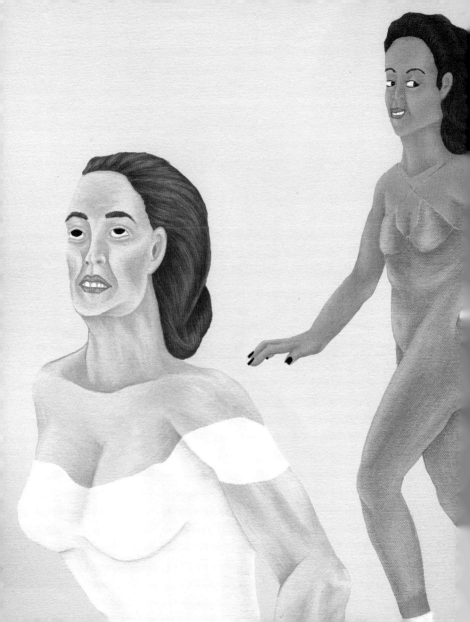

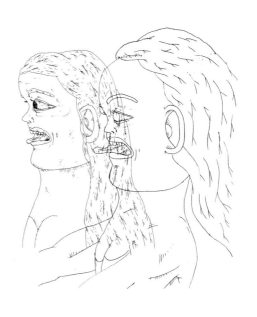

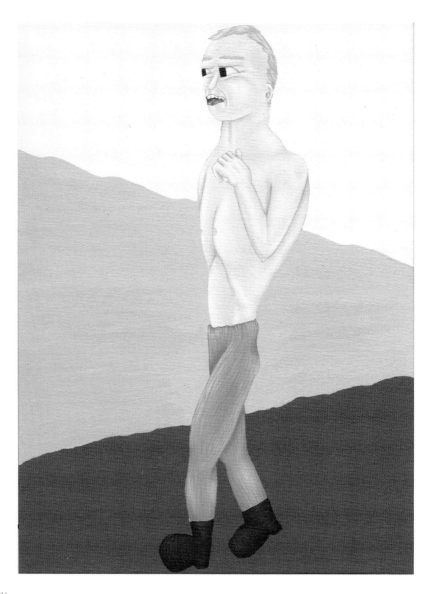

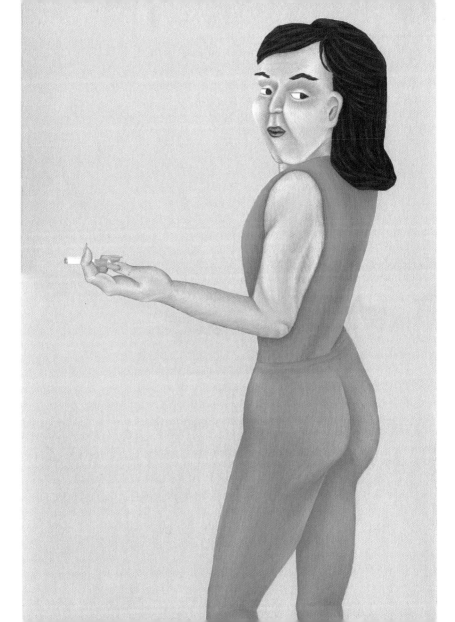

WALK FOR WALK

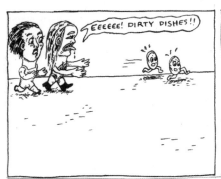

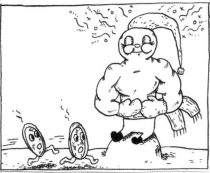

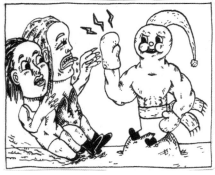

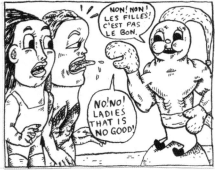

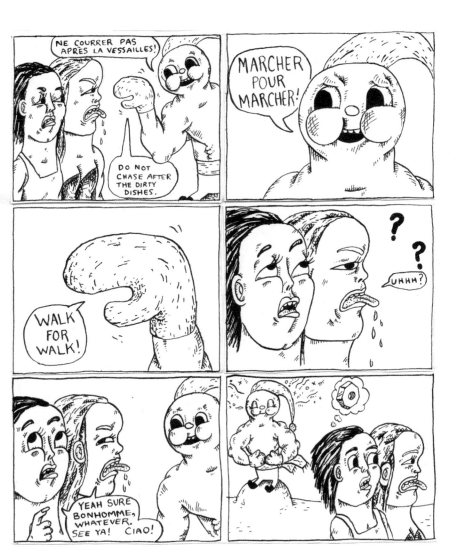

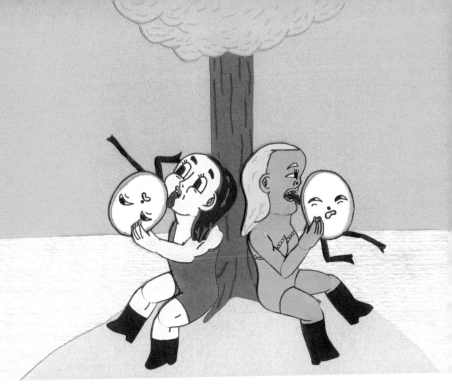

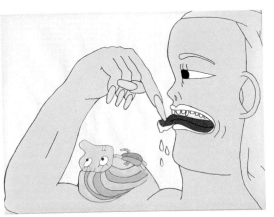

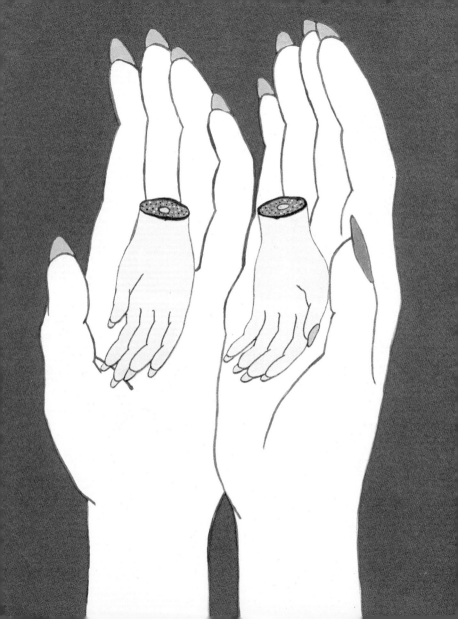

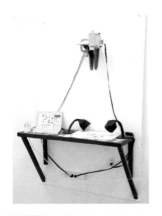

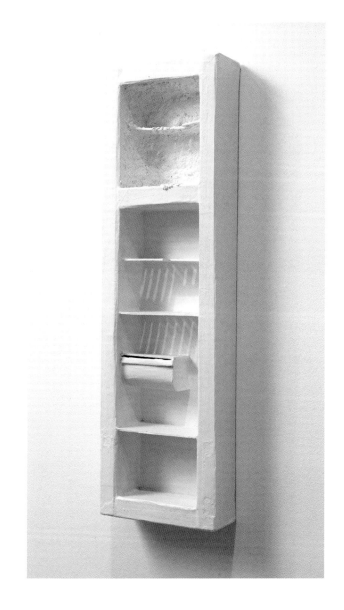

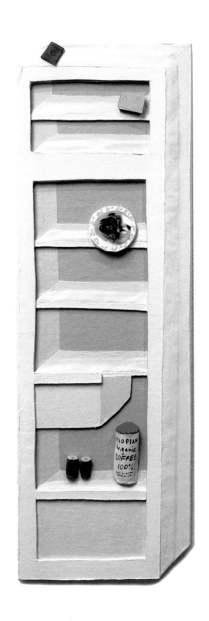

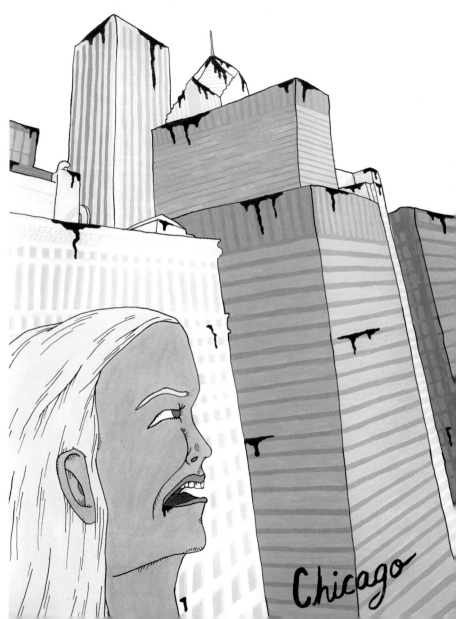

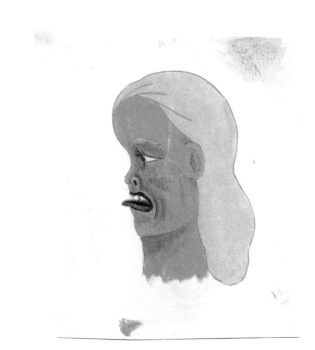

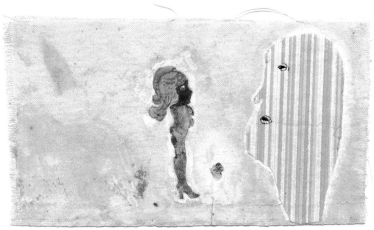

A TRUE STORY

WHOA! BIRTHDAY BIKE SHORTS

BY: AMY LOCKHART

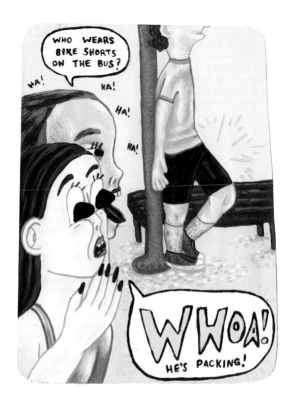

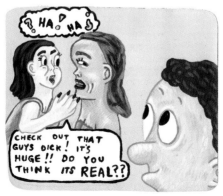

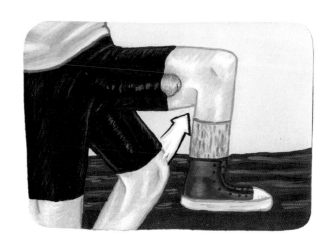

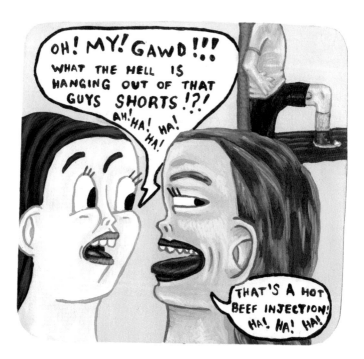

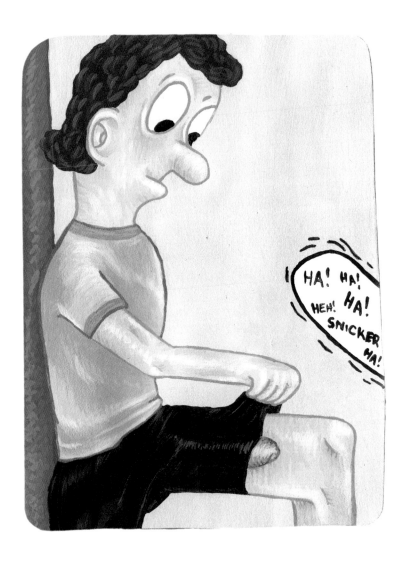

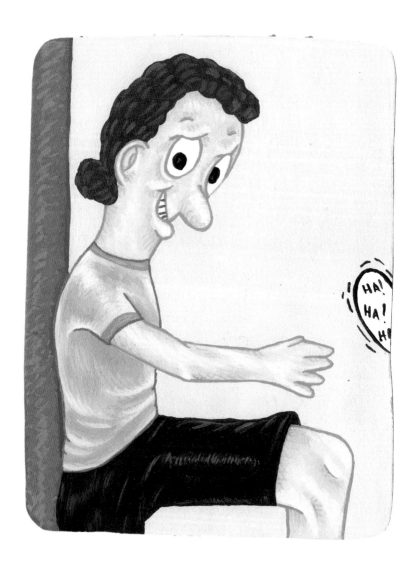

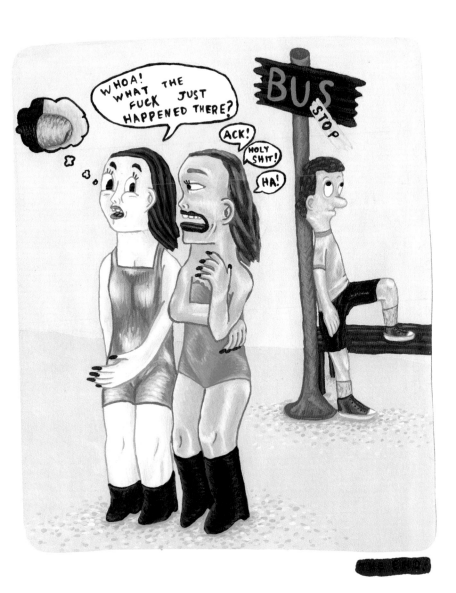

40

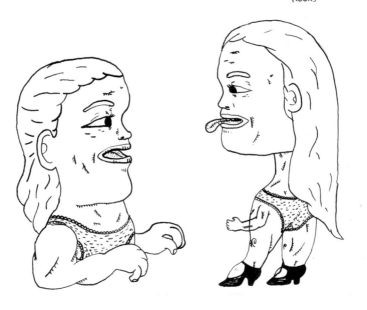

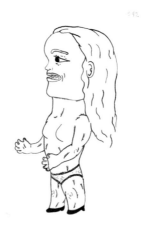

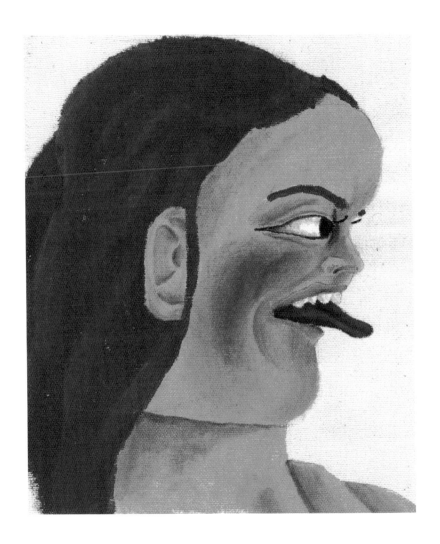

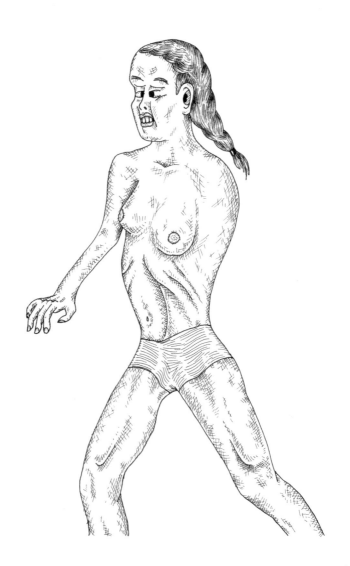

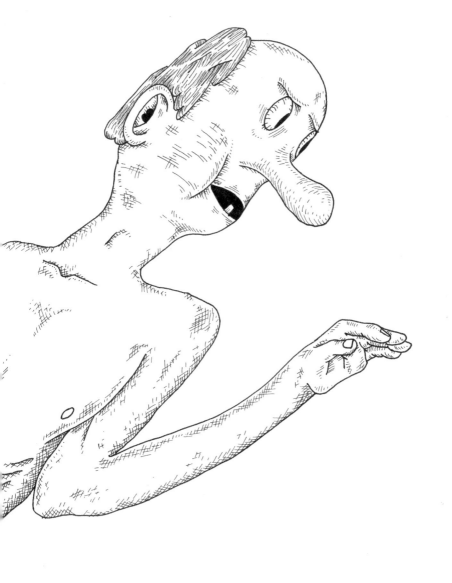

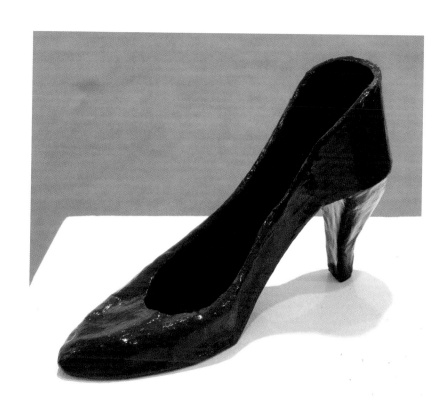

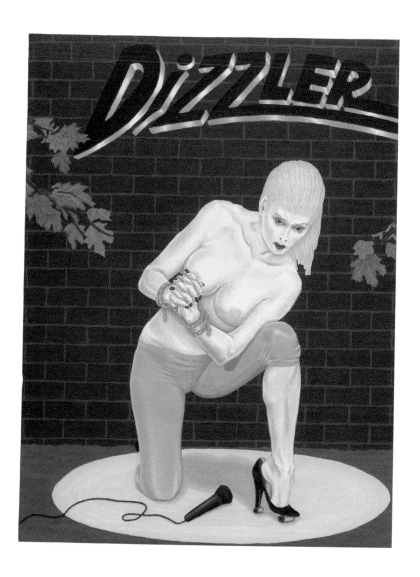

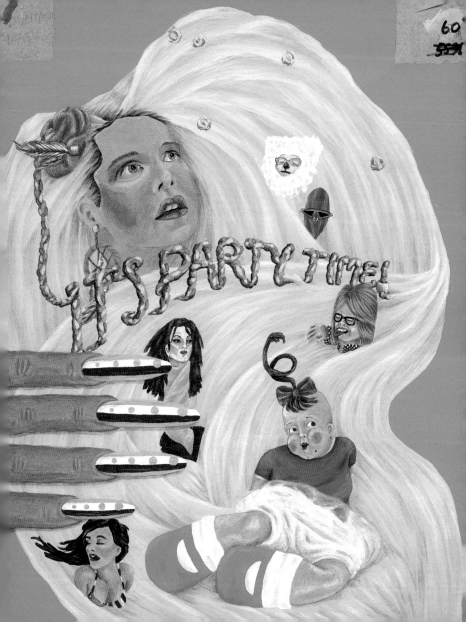

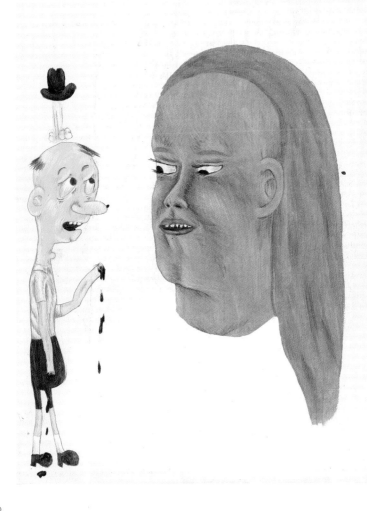

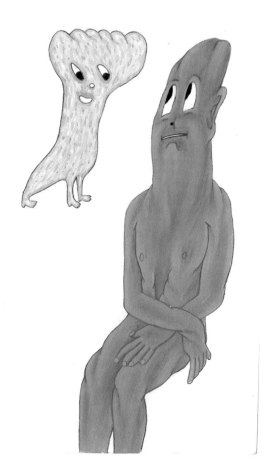

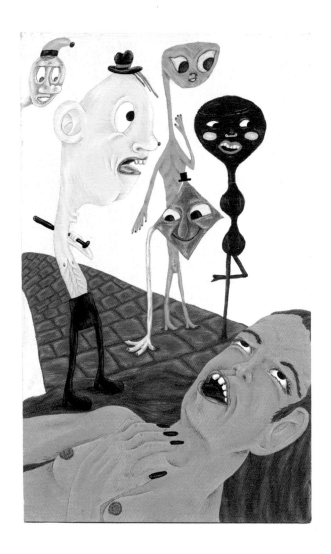

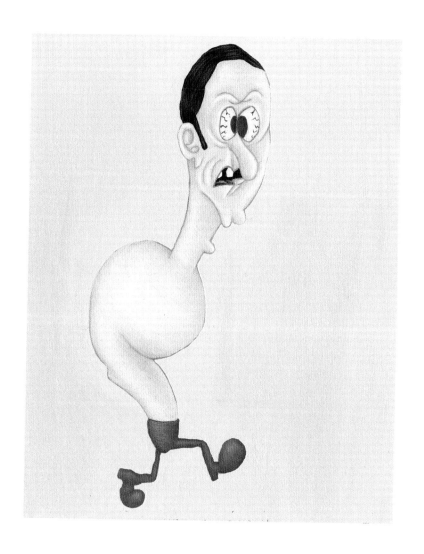

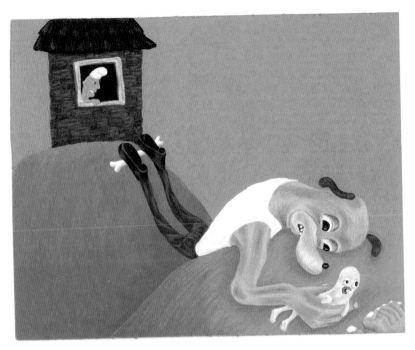

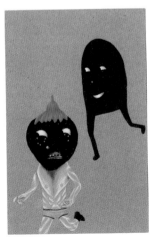

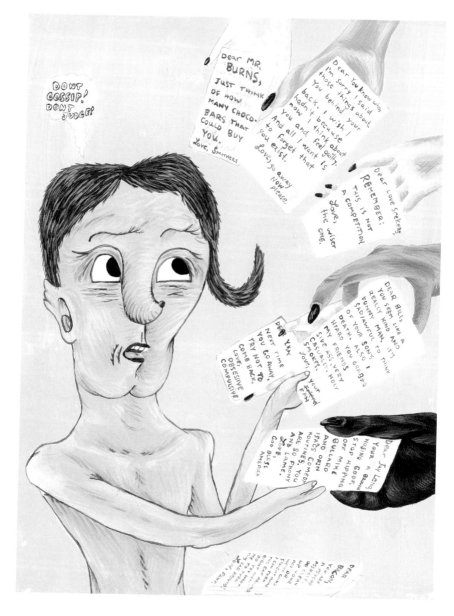

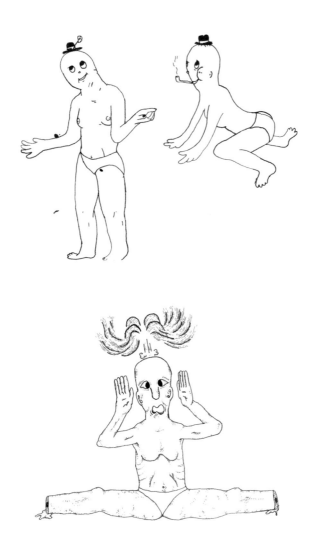

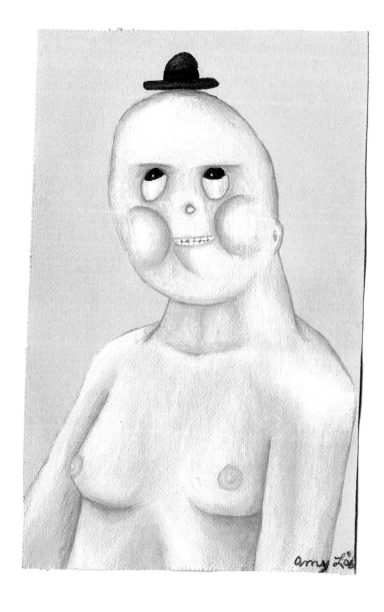

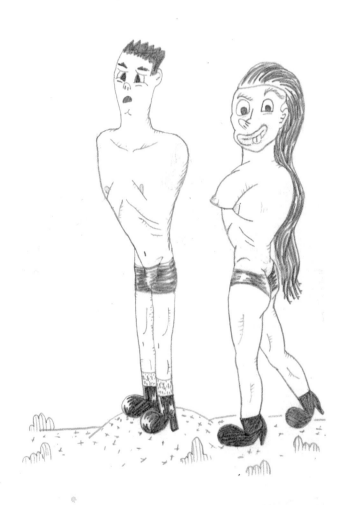

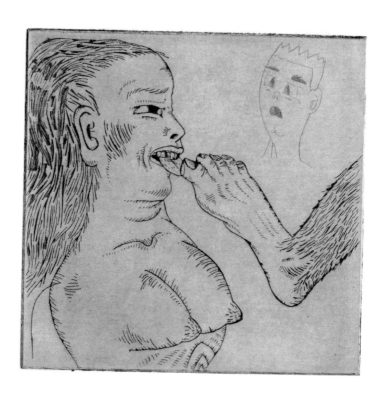

Frequently Asked Questions

Q: On the cover of *Dirty Dishes*, there are two ladies standing close together and one of them is breaking the wall. Why is she doing this?

A: The lady standing beside her just told her that this other lady (you can't see her, she's out of frame) was trash-talking her. She made it seem like she was telling her to be nice/honest with her friend but really she just wanted to see her friend freak out and put on a show for everyone.

Q: What are the two ladies fighting about on the first drawing in the book (on blue paper)?

A: I can't remember.

Q: Often in these drawings and paintings the persons in them have no arms and sometimes they are missing feet. Why is that?

A: I really like the torso shape, so removing the arms lets you focus on that. The feet, not so sure.

Q: The fridge-like sculpture on page 31 is called *Chicago Apartment* and the one on page 32 is called *Chicago Fridge*. Why is there this distinction?

A: The one called Chicago Fridge is a recreation of my actual fridge and contents while living in Chicago. The other one is called apartment as a joke. I was living in a highrise in the Loop (on Michigan Ave) surrounded by highrises and I would always say that they looked like fridges. All these people on deep freeze in their shelves, har dee har har...

Q: What is up with the *Red Shoe Of Human Rights* (page 45)?

A: Its a recreation/homage of this red shoe that was featured on "The Pollock and Pollock Gossip Show" on public television back in the day in Winnipeg, featuring Natalie and Ron Pollock. Natalie would wear them and dance around in sexy get ups and both her and Ron would refer to them as the red shoes of human rights. It was just genius.

Q: I am a little nervous to ask about the feet licking thing (with no arms) but I also don't really know what to ask about the "Marshmallow People" either (pages 56 and 57). I find them creepy. Do you have anything to say about any of those things?

A: I am not responsible for your hang-ups.

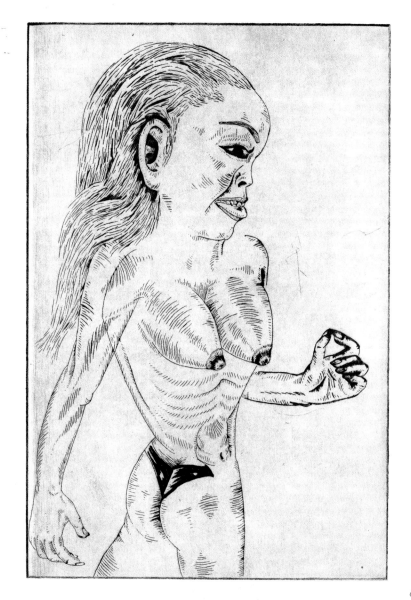

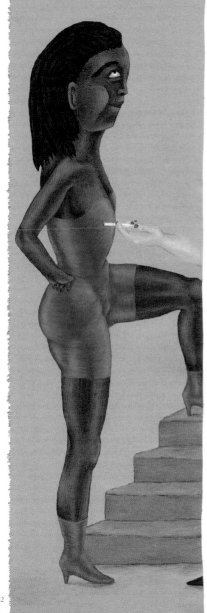

Index To Dirty Dishes

19. *Lady Runs to Forest*, acrylic on canvas

20. **Top:** *Lady with Dog and Tulips*, acrylic on canvas board
Bottom: *Man Made Uncomfortable by Lady*, ink on paper

21. *Lady looking*, acrylic on canvas

22-23. *Two Ladies Walking*, acrylic on canvas board

23. *Double Lady*, layered photocopy of drawings

24. *Man Walking in Landscape*, acrylic on canvas board

25. *Lady Smoking Cigarette*, acrylic on canvas board

26-27. "Walk For Walk" comic strip, ink on paper

28-29. Stills from "Walk For Walk" 16mm animated film, acrylic paint and paper

30. *Recreation of Video Animation Stand/set-up for "The Collagist"*, acrylic paint on cardboard and tape construction

31. *Chicago Apartment*, acrylic paint on paper construction with rice and dust

32. *Chicago Fridge*, acrylic paint on paper construction with sculpy

33. *Lady in Chicago*, acrylic ink on paper

34. **Top:** *Yellow Haired Lady,* acrylic on paper
Bottom: *Little Lady and Striped Head*, acrylic with paper collage on canvas

35–40. "Birthday Bikeshorts" comic strip commissioned for Kramers Ergot (rejected), acrylic on paper

41. *Kooks* #1 and #2, ink on paper

42. *Lady Portrait*, acrylic on canvas

43. *Young Lady with One Arm*, ink on paper

44. *Man on Ground,* ink on paper

45. *Red Shoe of Human Rights*, acrylic on paper construction

46. *Debbie*, acrylic on board

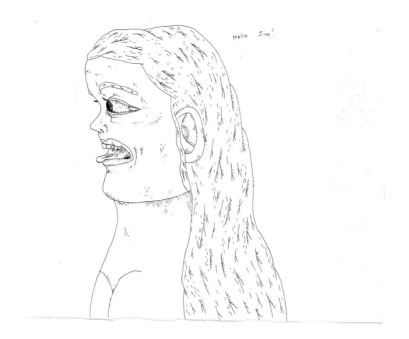

Hello Jim!

47. "Fake" *Dizzler* comic book cover, acrylic on board

48-49. Cover for VHS tape of *Miss Edmonton Teenburger in It's Party Time!*, acrylic on board

50. *Man with Hands Cut Off is Surprised by Lady Head*, acrylic on paper

51. *Yellow Guy with Blue Guy*, acrylic on paper

52. *Road Block*, acrylic on board

53. *Marc Walking*, acrylic on board

54. **Top:** *Not so fast! (Dog Trips on Bone)*, acrylic on board
Bottom: *Fudgesicle Chasing Strawberry Man*, acrylic on board

55. *Don't Gossip, Don't Judge*, acrylic on board

56. **Top:** *Marshmallow Ladies*, ink on paper
Bottom: *Lady with No Feet*, ink on paper

57. *Marshmallow Lady,* acrylic on canvas

58. *Couple with No Arms,* pencil on paper

59. *Lady with No Arms Licking Toes,* uneditioned etching

60. Frequently Asked Questions

61. *Torpedo Tits,* uneditioned etching

62. *Margarita At Stairs,* acrylic on canvas

63. *Study for painting of Andrea,* pencil on paper

64. *Study for painting of Ladies Walking,* pencil on paper

65. *Lady in Profile,* ink on paper

66. Found packaging used as inspiration for "lady" portraits

67. Lady Cross-Stitch, cross-stitch

69. *Self-Portrait as a Lady,* mixed media construction

70. *Auntie Har's Dogs,* acrylic on board

71. Amy Lockhart filming *Tell Mumsy I Love Her* on location in Toronto, ON

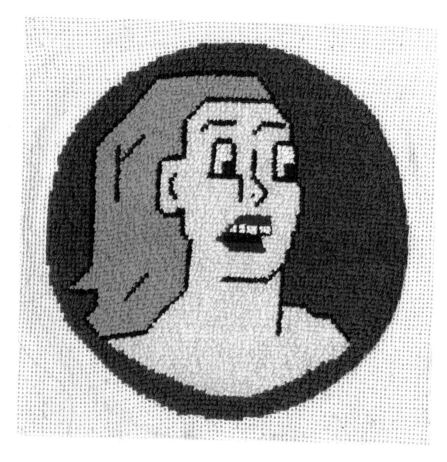

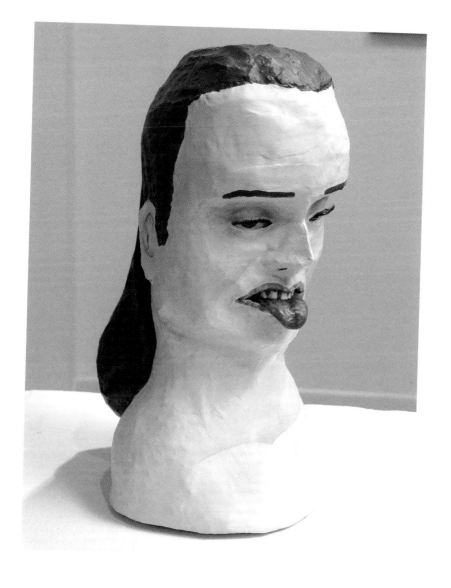

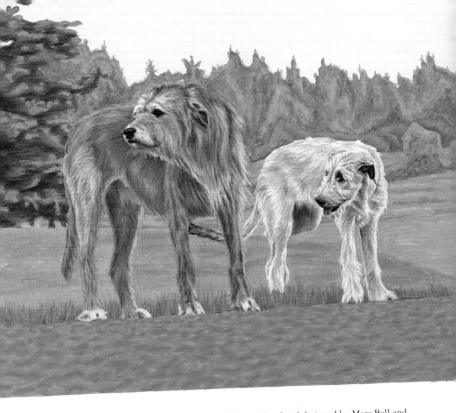

Entire contents © copyright 2009 by Amy Lockhart. Edited and designed by Marc Bell and Amy Lockhart. All rights reserved. No part of this book (except small portions for review purposes) may be reproduced in any form without written permission from Amy Lockhart or Drawn & Quarterly. Drawn & Quarterly; Post Office Box 48056, Montreal, Quebec, Canada H2V 4S8. www.drawnandquarterly.com; First Softcover Edition: December 2009. 10 9 8 7 6 5 4 3 2 1. Printed in Canada. Library and Archives Canada Cataloguing in Publication Lockhart, Amy, 1975- Dirty dishes / Amy Lockhart. ISBN 978-1-77046-004-1 1. Lockhart, Amy, 1975-. I. Title. N6549.L635D57 2009 741.5'971 C2009-906021-3; Drawn & Quarterly acknowledges the financial contribution of the Government of Canada through the Book Publishing Industry Development Program (BPIDP) and the Canada Council for the Arts for our publishing activities and for support of this edition. Distributed in the USA by: Farrar, Straus and Giroux; 18 West 18th Street, New York, NY 10011; Orders: 888.330.8477. Distributed in Canada by Raincoast Books; 9050 Shaughnessy Street, Vancouver, BC V6P 6E5; Orders: 800-663-5714.

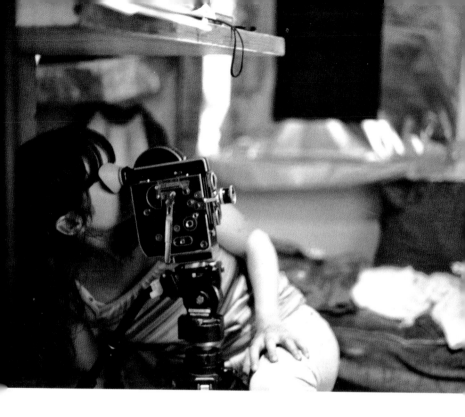

Amy Lockhart was born in Winnipeg and grew up in Ottawa, Canada. She studied at The Nova Scotia College of Art and Design and also educated herself in film and animation through attending Helen Hill's experimental animation workshop at AFCOOP in Halifax, completing an artist residency at the Quickdraw Animation Society in Calgary and a fellowship at the National Film Board in Montreal. Her artwork and award winning films have been exhibited internationally. She has completed residencies at The School of the Art Institute of Chicago and the California Institute of the Arts. This is the first book collection of her work.